BAILEY EXPOSED

David Bailey

NATIONAL PORTRAIT GALLERY, LONDON

Bailey:

"If you make your mark early on, you're lumbered with it. I bet Michelangelo said, 'Not another fucking ceiling!'"

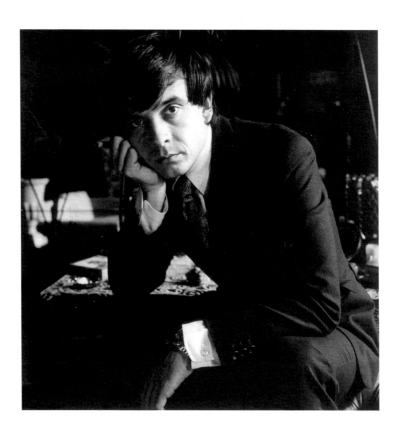

Bailey by Terry O'Neill, 1965

"I try to simplify things by just having a white background and no distractions. I don't care about 'composition' or anything like that. I just want the emotion of the person in the picture to come across ... to get something from that person, even if I have to force it out of them by being rude."

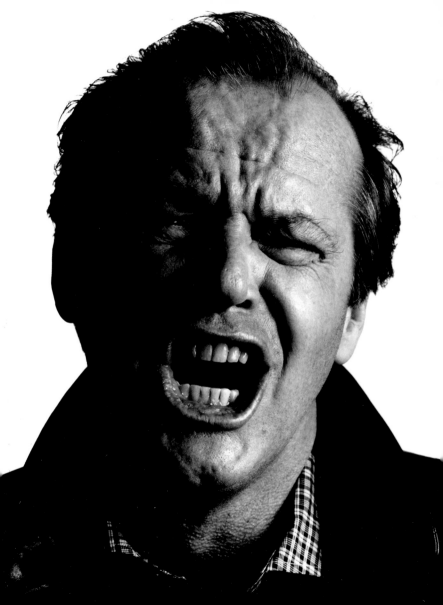

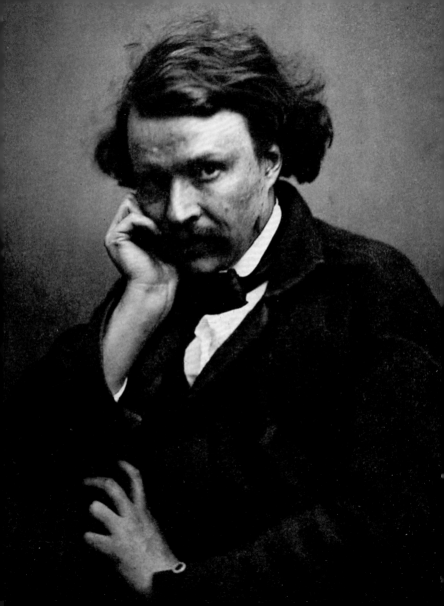

Bailey:

"The photographer that's closest to me I think is a French photographer of the 1860s – Nadar. When I look at his pictures I see my own pictures. He knew what I know, or I know what he knew – whatever."

Bailey:

"When I photograph people, directly they come through the door I'm already photographing them. You watch the way they move, and their personality, and which side of their face they prefer, and all sorts of things. What kind of mood they're in.

And it's like a Zen thing if they're in a bad mood then you encourage the bad mood; then you get something from the pic And if they're in a good mood, you encourage the good mood."

"...ll started in London's East End, where I was born on the street next to Fred Hitchcock's."

Bailey:

"I think he was charming, my father. I didn't know him that much. I never saw him that much. He was always scallywagging, up to no good, I think, with women. And my mother was kind of like a tough old gypsy – she even looked like a gypsy."

Bailey's first photograph: his parents and sister Thelma, Margate, c.1948

Hitler Killed the Duck, David Bailey, 2007

Bailey:

"When I was, I suppose, six, I went to see *Bambi* and small cartoons in the cinema. And then one of Hitler's V2 rockets destroyed the cinema at Upton Park. From that moment on, I thought Hitler had killed Bambi and Mickey Mouse and everybody."

Bailey:

"The first thing visual I remember were Hollywood movies. I loved the way they used to light things. Even as a kid I was fascinated by John Ford movies, and Hitchcock, for sure. And later I liked very much the French New Wave. And then the Italians – I like very much Fellini, who suffocated you with bad taste, and then Visconti, who suffocated you with good taste."

Luchino Visconti, 1970

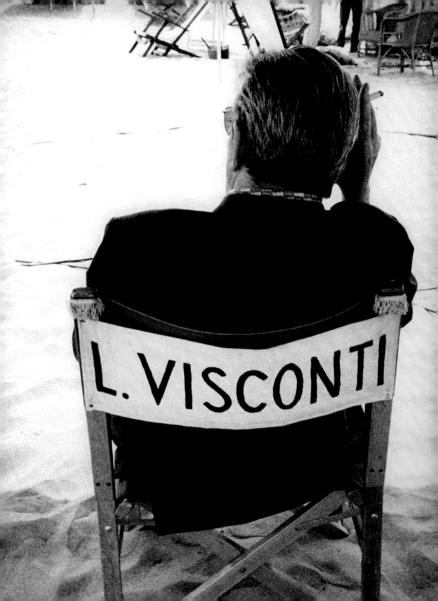

"My whole cultural influence is really Hollywood – old Hollywood, Forties Hollywood. We'd go to the cinema seven times a week. It was cheaper than staying home; you didn't have to put money into the gas machine that kept the fires going in the house. I think when I was around twelve my heroes were Fred Astaire, John Huston, and an ornithologist named James Fisher. I thought Fred Astaire was the most glamorous thing in the world. And I thought John Huston was like a white hunter."

John Huston, 1965

Martin Harrison:

"An important thing about Bailey is his interest in birds ... I think identifying birds and knowing what species a bird is is part of this close looking that he does. They're fleeting images, they fly off. It's a fairly natural transition from studying birds to being the man who captures the fleeting moment of something that happens in the world, in life, with his camera."

Self-portrait with a cockatoo, 1975

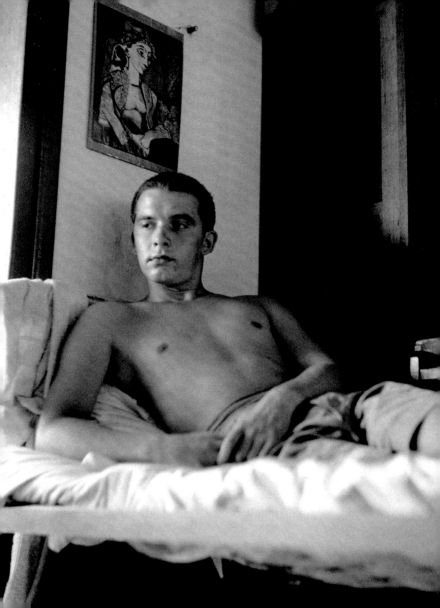

"My biggest influence, in a funny sort of way, was Picasso. The thing that Picasso taught me was that there are no rules. He taught me that a circle doesn't have to be round – which was a good lesson."

Self-portrait during National Service in Singapore, 1957

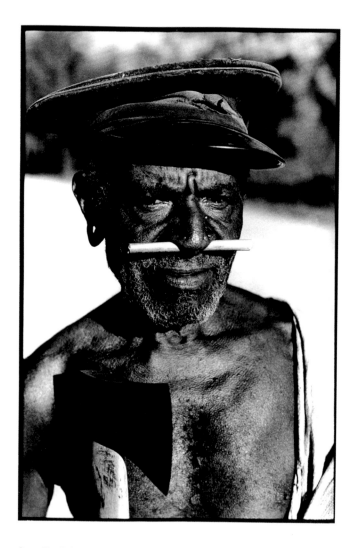

Papua New Guinea, 1974

Bailey:

"It takes a lot of imagination to be a good photographer. You need less imagination to be a painter, because you can invent things. But in photography everything is so ordinary; it takes a lot of looking before you learn to see the extraordinary."

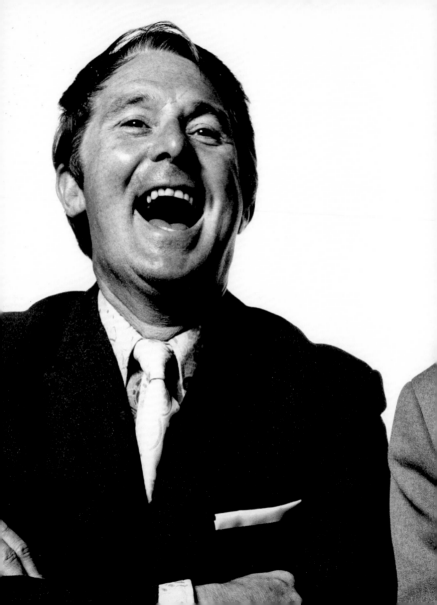

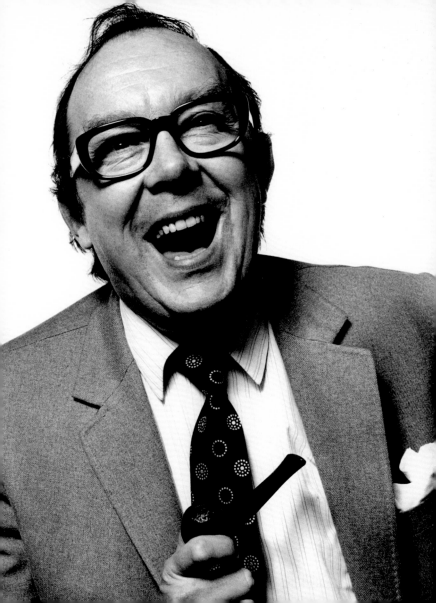

Bailey:

"I like laughing.
That's the
story of my life,
really. It's been
a bit of a laugh.

Cockneys
don't cry. If
you cried, you
got thumped."

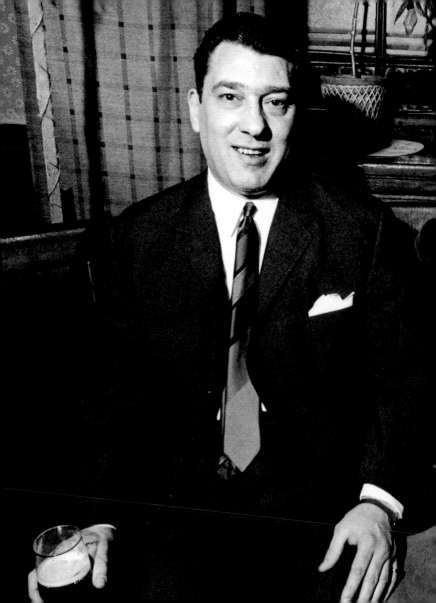

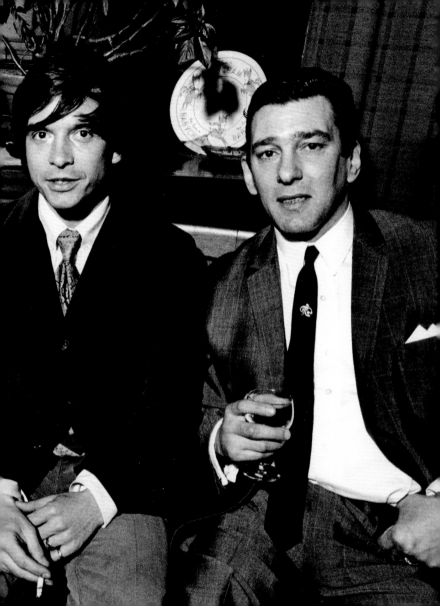

Bailey:

"The Krays were just part of my youth really, because people didn't see much difference

between the police and the gangsters in the East End. They were pretty much the same thing."

"Ronnie was a bit of a worry, because you never knew which way he was going to turn, but Reg was all right – I mean apart from he killed people! I lived with them for two weeks for *The Sunday Times*, and then we couldn't publish the pictures because they got arrested. They remind me a bit of the Cossaks – they had their own code of morality. They wouldn't have anything to do with prostitution or drugs, because they thought it was immoral. It was all right to chop off somebody's head, but not be a prostitute."

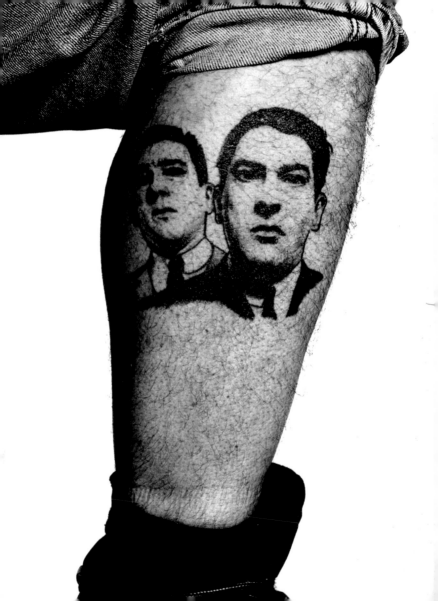

ailey:

"can't bear butch men. I'd rather be with lesbians."

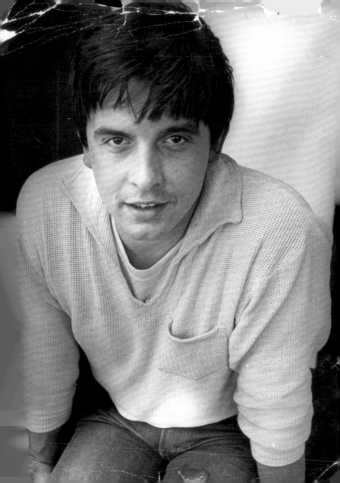

Bailey:

"I said a lot of stupid things before I was 25. Things that, ever since, I've had to spend my life adjusting or denying."

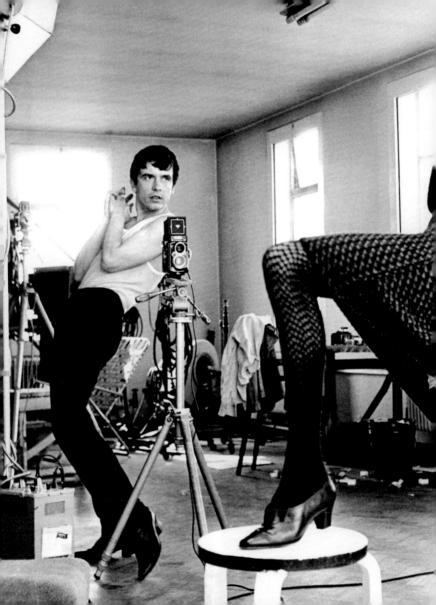

Bailey:

"I never considered myself a fashion photographer. I've never really been interested in fashion. The reason I did fashion was that I liked what was in the frocks."

Bailey photographing Sue Murray by Terry O'Neill, 1965

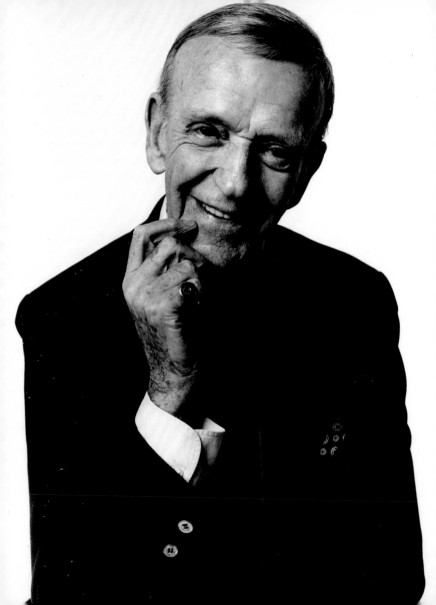

"There's a difference between style and fashion. Style's much more important."

Diana Vreeland:

"Irving Penn's studio is like a cathedral. David Bailey's studio is like a nightclub."

Diana Vreeland, 1967

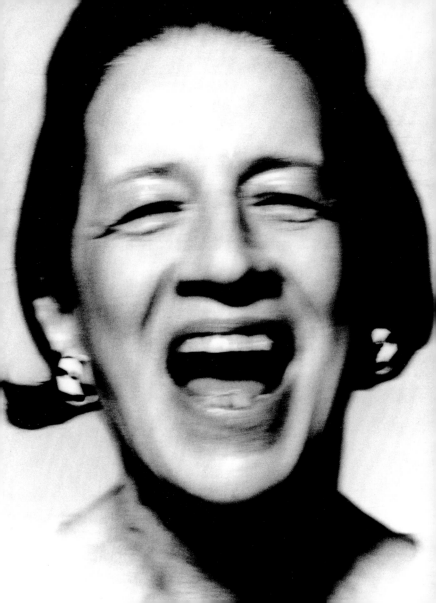

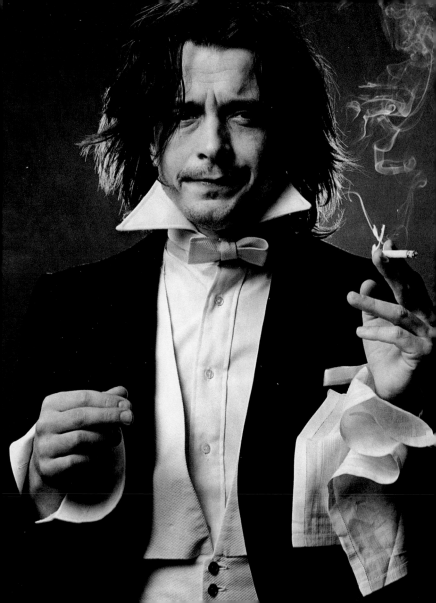

Bailey:

"People suddenly realised that even if you didn't have the 'right' accent you could still do things. It was as much a social revolution as anything. When I first went to work at *Vogue* they used to pat me on the head and say, 'Oh, doesn't he speak cute?' I'll give you cute. Within nine months, the managing director was asking me if I'd mind moving my Rolls-Royce so he could get his Ford out."

"They used to think I was my assistant sometimes — that was always amusing, and I never put them straight. I used to take the pictures round to the magazine and they would say, 'Tell Mr Bailey we like them.'"

Bailey by Patrick Lichfield, 1969

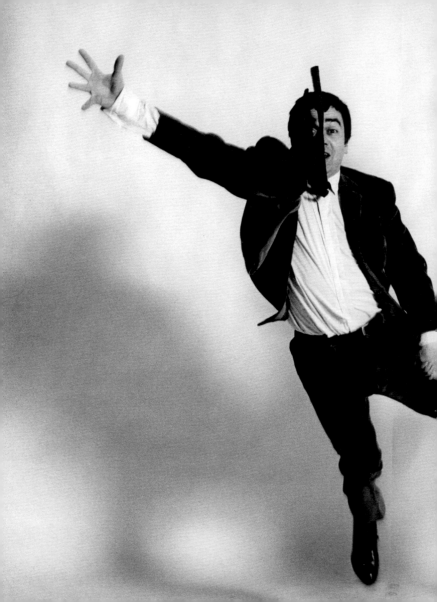

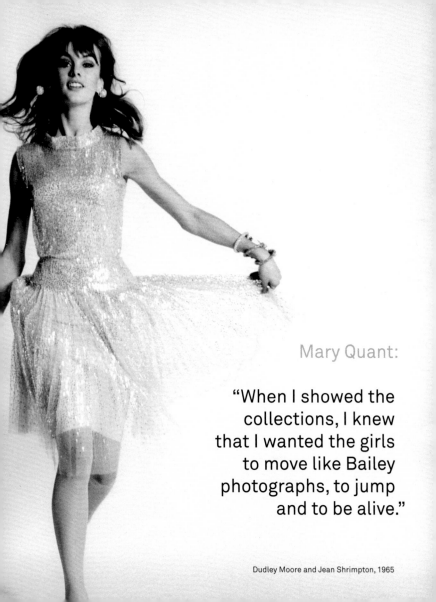

Mary Quant:

"When I showed the collections, I knew that I wanted the girls to move like Bailey photographs, to jump and to be alive."

Dudley Moore and Jean Shrimpton, 1965

Grace Coddington:

"It was the Sixties, it was a raving time, and Bailey was unbelievably good-looking. He was everything that you wanted him to be – like the Beatles but accessible – and when he went on the market everyone went in. We were all killing ourselves to be his model, although he hooked up with Jean Shrimpton pretty quickly."

Grace Coddington, 1966

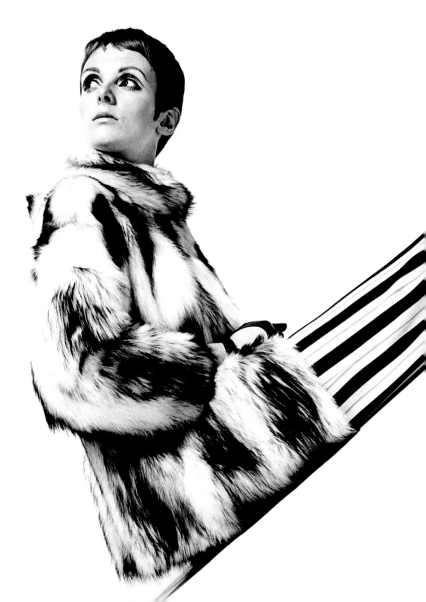

Bailey:

"One day I walked past one of the studios and there was this vision, this girl with these blue eyes, being photographed for a cereal ad. She took my breath away. I said, 'Who's that?' And the photographer who was shooting her said, 'This girl's called Jean.' I said, 'I think she's great.' He said, 'She's too posh for you. You don't stand a chance.'"

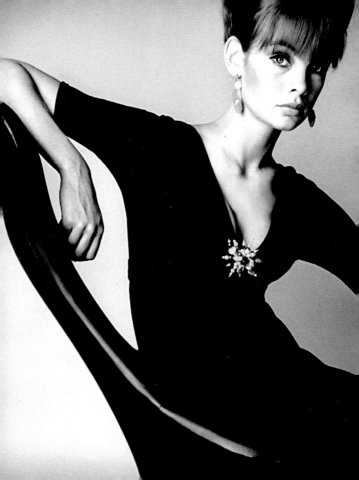

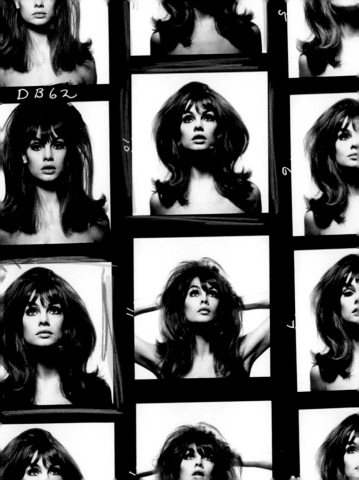

DB62

"I think most talent is inborn. So Jean had an advantage because she was very beautiful. Jean didn't scare people ... she was attractive to everybody, from dogs to intellectuals. She had one of those democratic beauties that everyone could appreciate. She could possibly live next door. Some women are so beautiful that you can't believe they could live next door; they live in some fantasy world."

Jean Shrimpton contact sheet, 1965

Bailey:

"Faces don't have to be beautiful. I mean, look at Sophia Loren. She's got a dodgy nose, dodgy mouth, funny little round face. But she's one of the most beautiful people in the world."

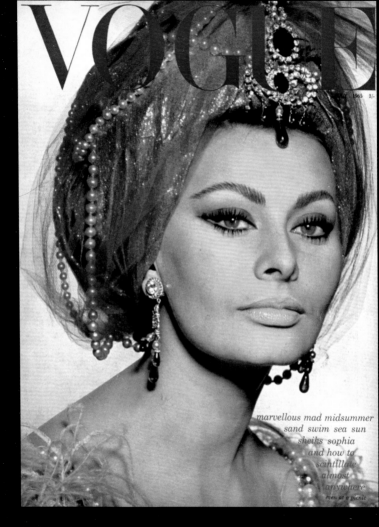

VOGUE

*marvellous mad midsummer
sand swim sea sun
sheiks sophia
and how to
scintillate
almost
anywhere*
even at a picnic

Sophia Loren, *Vogue*, July 1965

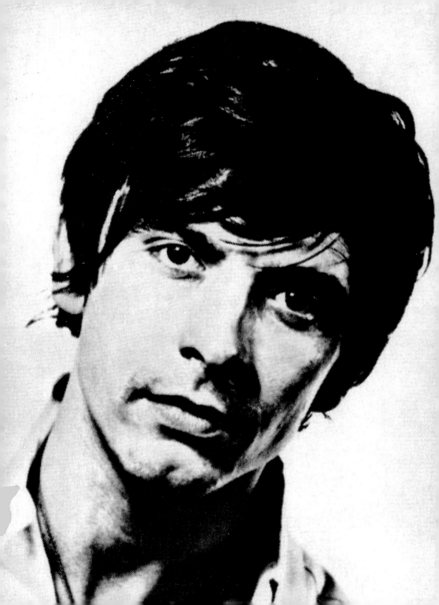

Bailey:

"Being handsome wasn't much of a burden. It worked for me."

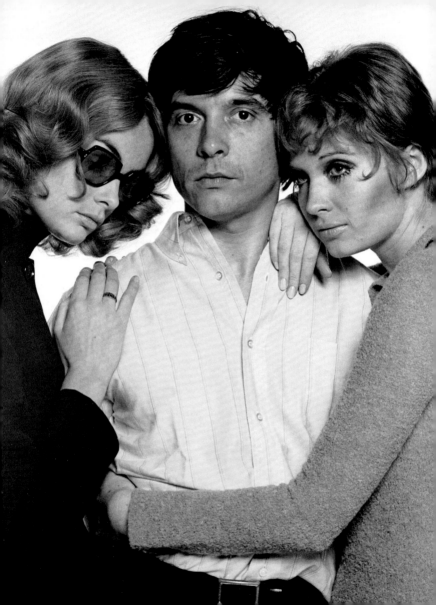

Bailey:

"Sex gets better as you get older. Much better. Like anything in life, it's practice. And I had a long apprenticeship."

Catherine Deneuve:

"We got married pretty quickly. It was very romantic, after only a few months or even weeks ... What fascinated me was his unpredictability, his whimsical outlook. I like British eccentricity and he's pretty eccentric."

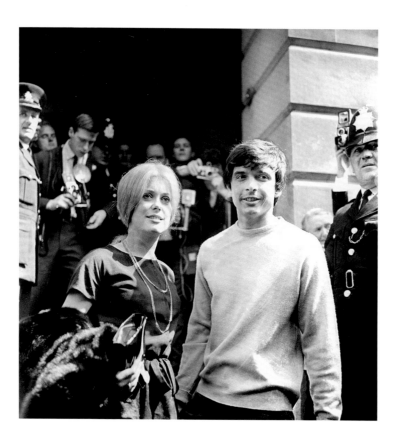

Bailey with Catherine Deneuve on their wedding day, St Pancras, London, August 1965

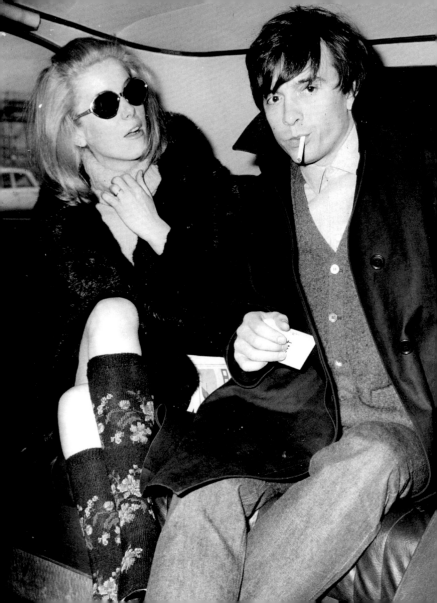

"Posh? I don't know. We never really worked that one out. I think we both thought we were more intelligent than we were, because she couldn't understand what I was saying and I couldn't understand what she was saying, so we used to give each other the benefit of the doubt."

Bailey with Catherine Deneuve, 1966

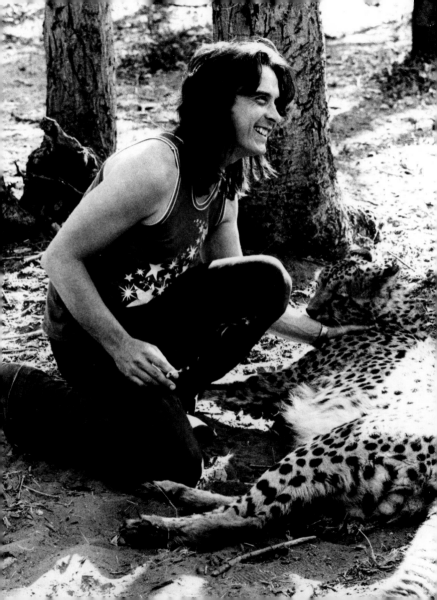

Penelope Tree:

"The king lion on the Savannah: incredibly attractive, with a dangerous vibe. He was the electricity, the brightest, most powerful, most talented, most energetic force at the magazine [British *Vogue*]."

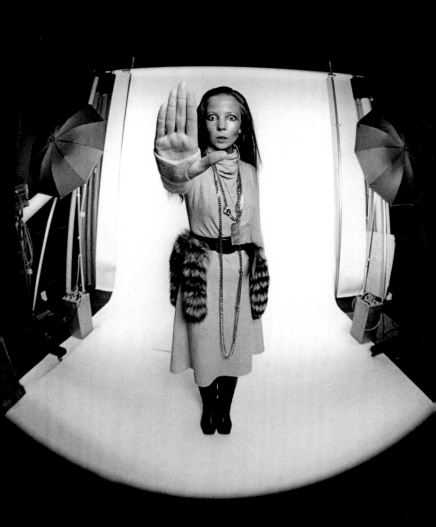

Bailey:

"I've always been considered difficult, which I've never understood. I think people think I'm difficult because I know what I want, and I figure if they've asked me to do something then they should let me do what I do, and not say, 'We want a silver background.' Because I don't really do silver backgrounds."

Brian Duffy:

"If you're going to have a best friend, you might as well have a shithead. That's how I'd describe my relationship with Bailey. He's always been the same. He's always been straight, honest, shitty. That's why he's honest. Yeah – a shithead."

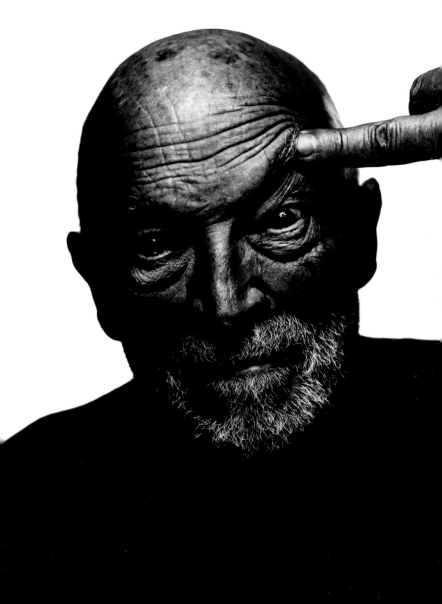

Terence Donovan:

"There is one thing always absent from David Bailey's photography – banality."

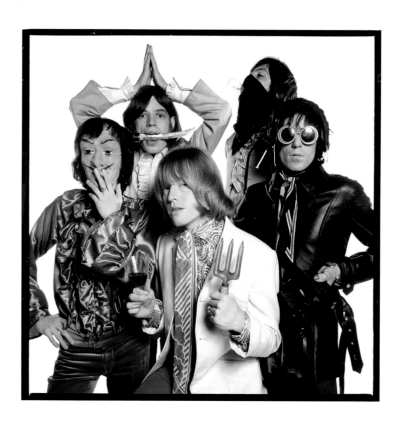

The Rolling Stones, 1968

Bailey:

"The Stones over The Beatles, no question. They're from London."

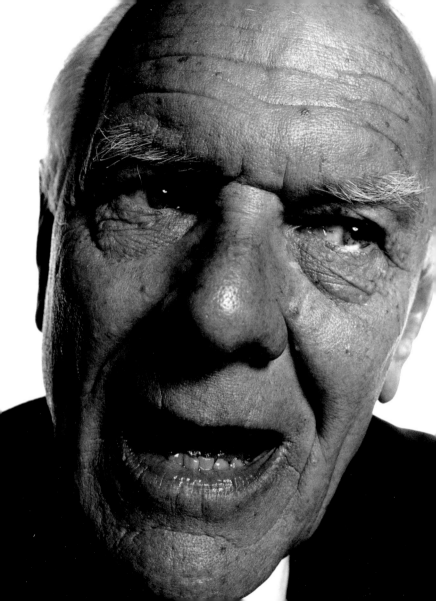

Malcolm Muggeridge on Bailey:

"The evil eye of the twentieth century."

Malcolm Muggeridge, 1968

"Bailey, a dark, Raeburnesque boy, with lots of picturesque gear and an eye for beautiful girls, at once showed vast assurance – even bravura. Also he had a talent for the 'way out' at a time when a change was needed. Bailey has always had a desire to shock."

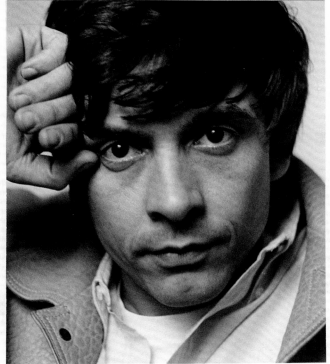

Bailey:

"It's not the camera that takes the picture; it's the person."

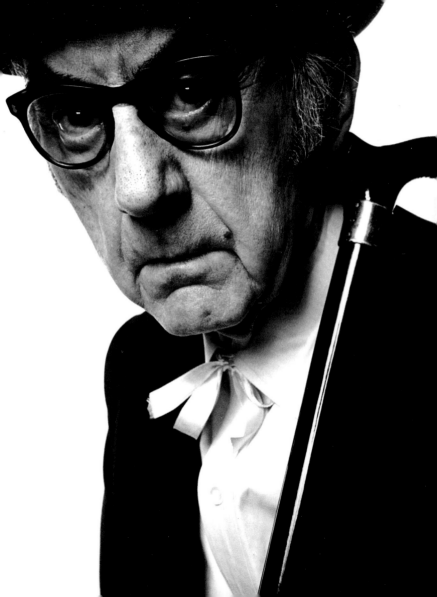

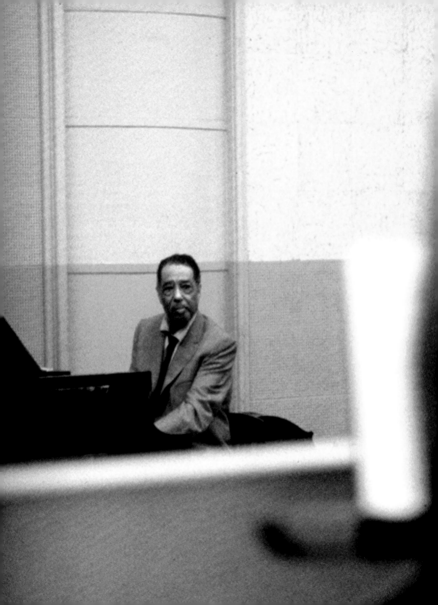

George Melly:

"His method, as I have observed it on several occasions, is to buzz insect-like around his subject, using roll after roll of film while keeping up a monologue of seductive encouragement. Some might think that anybody could take a good photograph in this way, but the point is that the end result could be by no one but Bailey. Whether the explanation lies in his ability to recognise the right image on the contact sheets, or his skill in cropping it or printing it, the final photograph is always remarkable. In my view, only a handful of photographers, Man Ray for instance, had this ability to impose an individual vision on a mechanical process again and again."

George Melly, 1981

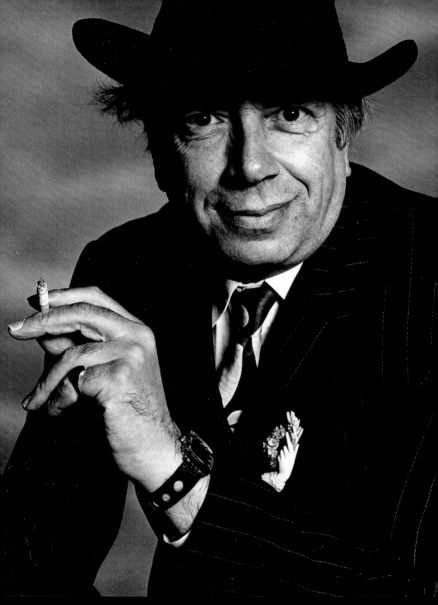

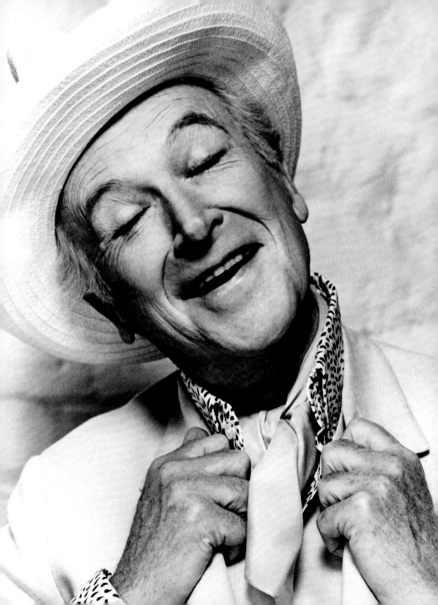

"I suppose I've got a gay side because I'm totally comfortable with gay men ... and I have a 'gay' understanding of women. I love the way my mother looks."

Cecil Beaton, 1970

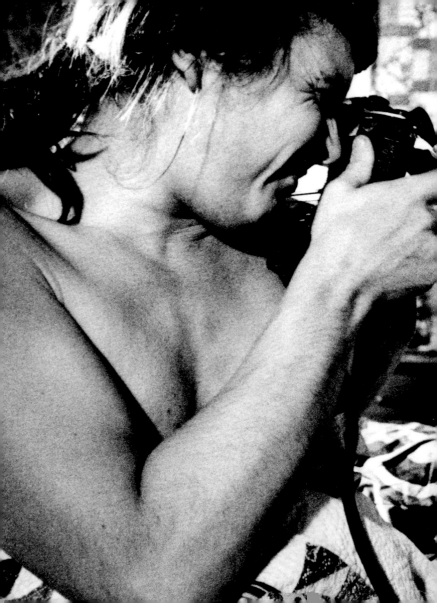

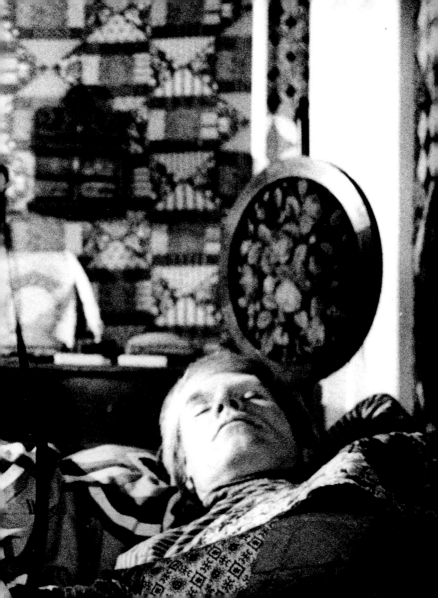

Bailey:

"I had offers from beautiful men. Nureyev. Helmut Berger. But I was never tempted. Never, never, never."

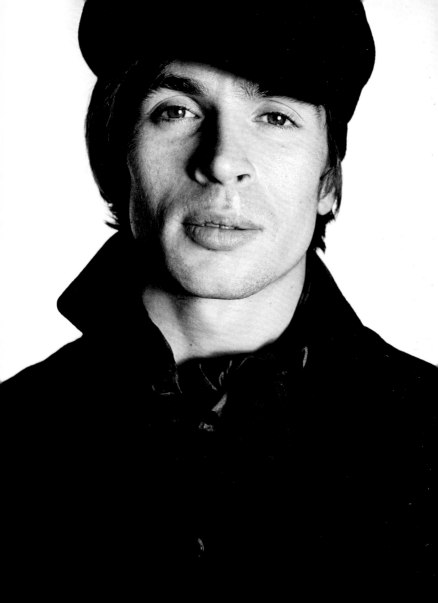

"I'm unpolitical. My father was a shop steward, a leftie. Then they made him a foreman and he became a Tory overnight."

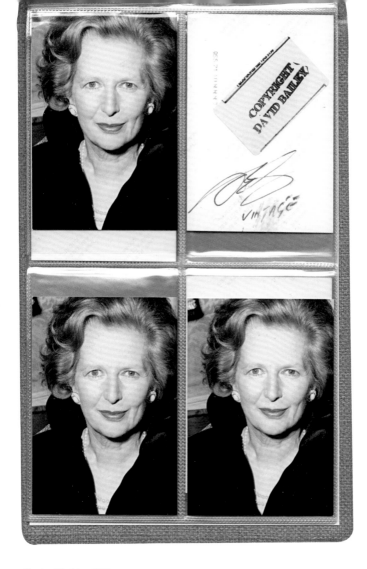

Margaret Thatcher, 1985

DESCRIPTION SIGNALEMENT

	Bearer Titulaire	★Wife Femme
Profession Profession	PHOTOGRAPHY FASHION	
Place and date of birth Lieu et date de naissance	LEYTONSTONE 2-1-1938	
Country of Residence Pays de Résidence	ENGLAND	
Height Taille	5 ft. 8¾ in.	ft. in.
Colour of eyes Couleur des yeux	BROWN	
Colour of hair Couleur des cheveux	BROWN	
Special peculiarities Signes particuliers		

★CHILDREN ENFANTS

Name Nom	Date of birth Date de naissance	Sex Sexe

Usual signature of bearer
Signature du titulaire

Usual signature of wife
Signature de sa femme

Bailey:

"My style is nothing. It sounds really pretentious – my way of making everything minimal. Just concentrating on the person and getting rid of everything else. It's just the person I want – that's the only thing I want – I don't want anything else. I don't want their hands or silly things that look like they're on the back of a book. I just want very sophisticated passport pictures really – which are quite hard to do!"

Bailey:

"The pictures don't get better the longer you're around the subject. The moment's the moment. And you don't want them to be bored with you either, because the magic goes. You have to get the magic quick. If I go to Delhi, I get off the plane and I start photographing, because five days later it all starts to look normal."

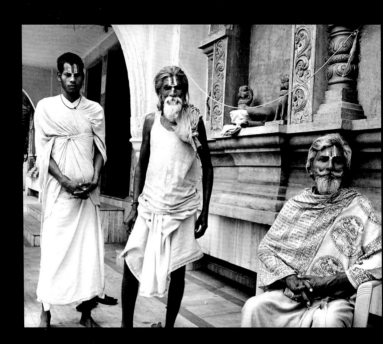

Delhi, 2011

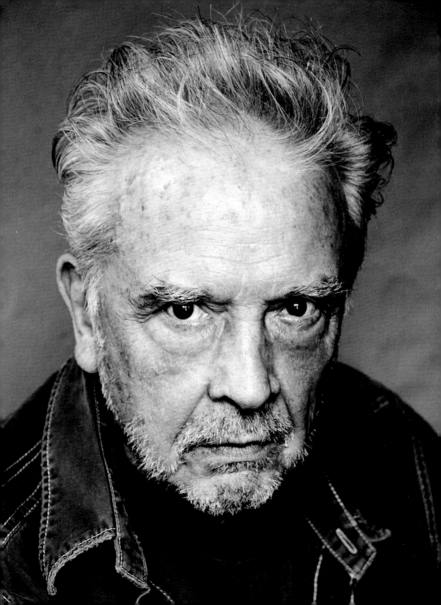

Catherine Deneuve:

"There's a lot of discipline, a lot of power in his photos. And something animalistic, even when he photographs young women and models. I like the feral aspect. Something he can't rein in. It's him and he can't hold back. I like men who have retained a boyishness. If you compare him to Avedon or Penn, his work is more visceral."

Self-portrait, 2011

Anjelica Huston:

"Bailey has a glint in his eye. He doesn't just have a camera up to his eye – he has a point of view; a very specific idea about what he's photographing ... Working with Bailey was always flirting; it was teasing, it was funny, it was witty, it was always, always a trip, always an adventure."

Bailey:

"She's just wonderful, Anjelica. I like people who make their own beauty, and she's become beautiful because she's Anjelica. Look at her face – everything's wrong, but when you put the jigsaw puzzle together, it all works."

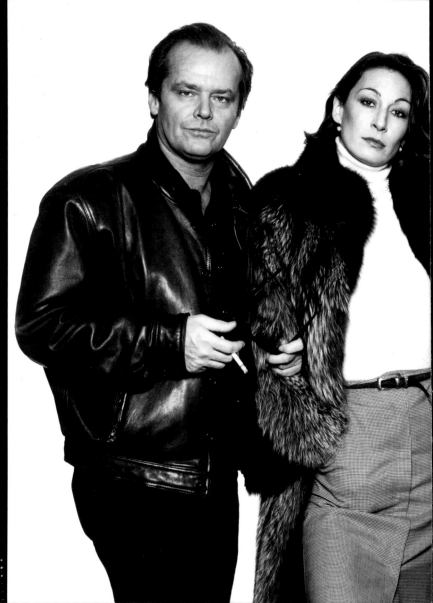

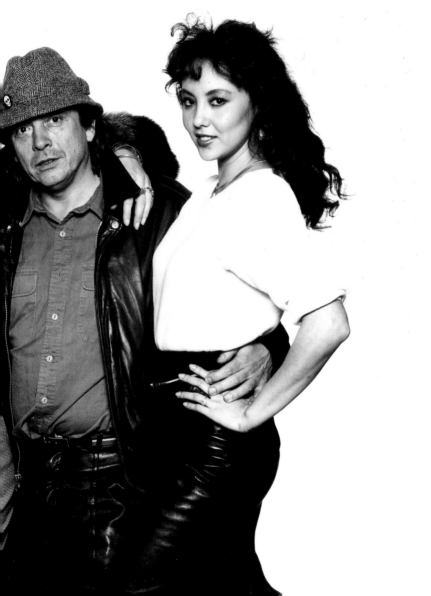

Bailey:

"Everyone is going to take one great picture in their life and hopefully I'll do two so I'll have the edge."

Andy Warhol, 1965

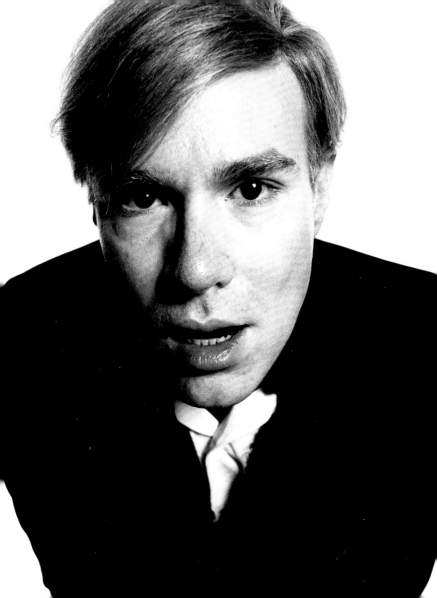

"She's so beautiful, Kate Moss, isn't she? She's so beautiful without being beautiful – it's amazing. She's just beautiful. I've only known two models that were like this – Jean Shrimpton and Kate Moss. They're unique. I can't understand it."

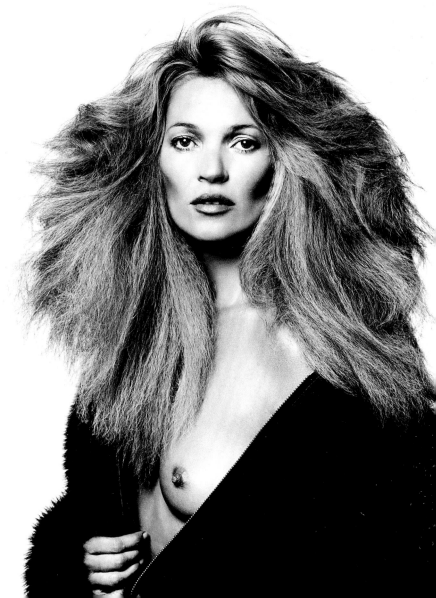

Paul Smith:

"He's interesting because
he wants to make women
beautiful and men appear
honestly, just exactly how they
are. He's a lover of women, so
he always makes them look
great, and with men there is
always this stark element.
He has such confidence in
his work, and it's true that he
really moved the dinosaur

that was formulaic fashion photography into a new era of spontaneity. Cartier-Bresson had mastered the 'caught moment' of someone drinking coffee or crossing the road, but Bailey did the same with fashion. Nobody likes change, ever – but he was strong and he made it acceptable."

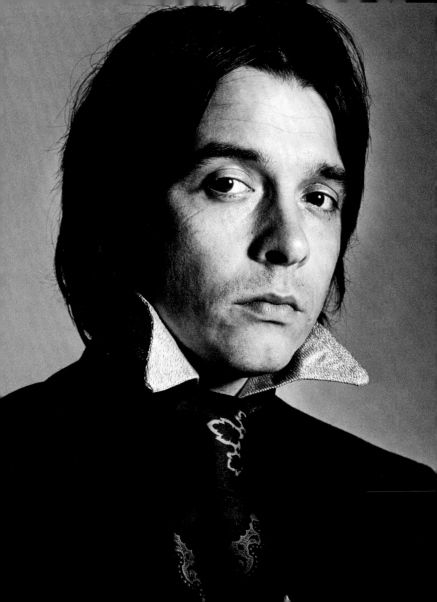

Bailey:

"It's like being a vampire. I want to capture their personality."

Kenneth Williams:

Diaries – Monday, 2 December 1968

At 11.30 to the photographer David Bailey at Gloucester Ave. He just chatted to me and took photographs and I was away by 12 o'c. He's a young fellow – only about 25 and v. mod and with it. He made me laugh when he said 'You can't be a royal photographer if you've been divorced' & I said 'Have you?' and he said 'Oh! yes – three or four times ...'

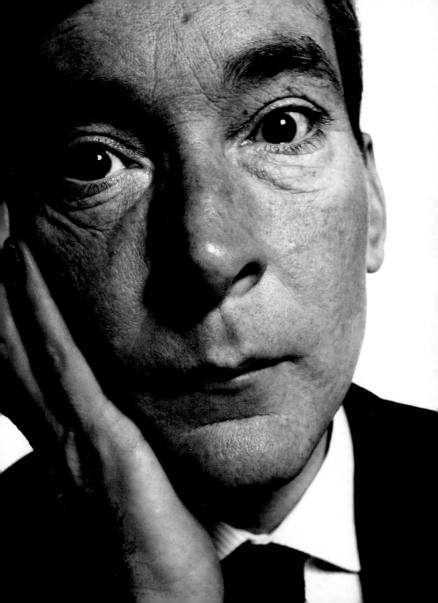

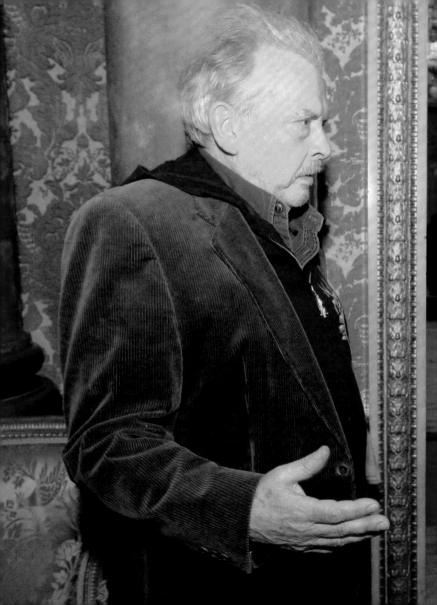

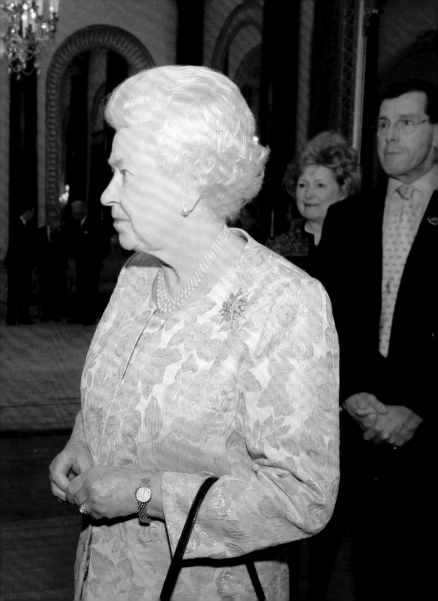

Bailey:

"The Queen is one of my favourite women in the world. She's funny. I got given the CBE – it's nice to get something.

Prince Charles said, 'It's nice to see you here.' I said, 'I want to get one thing straight, Charles – I'm not joining, I'm infiltrating.'"

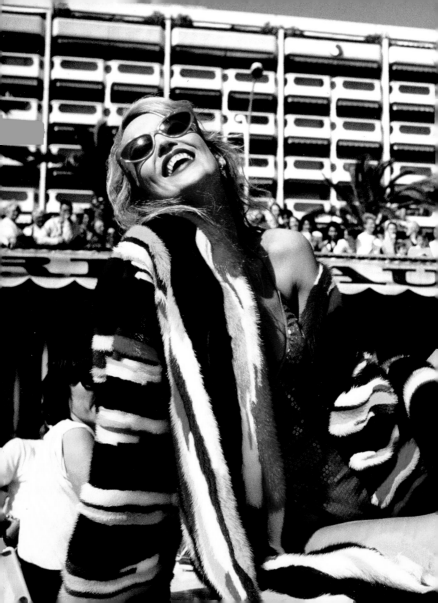

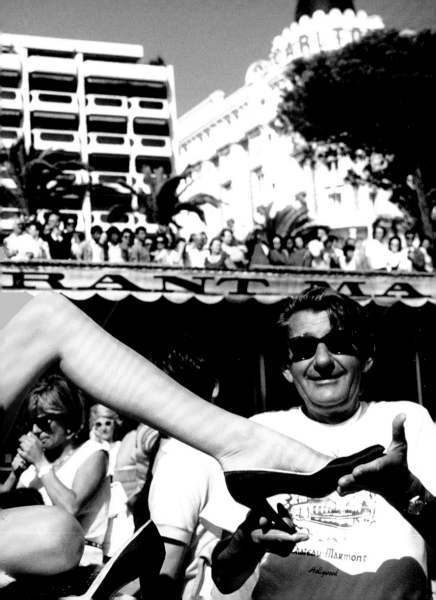

Jerry Hall:

"I have a great time working with him. I love working with him. He makes me laugh. The day goes by very nicely. It's pleasant.

When he's looking at you, you 'feel' what he's looking. You feel more beautiful, more sexy. ... There's a very silent language that goes on between the model and the photographer. It's like when someone loves you, it brings out the best in you. And when you feel the look of someone

Previous pages:
Jerry Hall with Helmut Newton, 1973

who loves you, you just sort of blossom. I think that happens with a great photographer, with Bailey. I think he adores women and he adores beauty, and I think he admires it so much that he brings it out in you.

I think it's very flattering to be a great muse to a great photographer or a great artist. I think it's wonderful, kind of magical. It makes you immortal in some way."

Bailey:

"I think photography's sexual – unlike Mr Avedon, who thought it wasn't. Even with men. I suppose I fall in love; when they're in front of the camera, they're everything to me. I mean, they are the object of my love for that brief encounter."

o

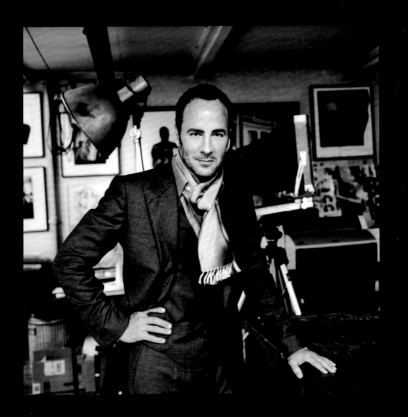

Tom Ford, 2006

Jean Shrimpton:

"Women love him. Gays adore him. Children and animals run to him. Mothers dote on him. He is universally attractive, except to fathers."

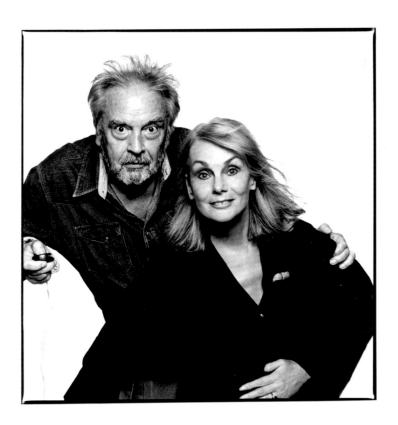

Bailey with Jean Shrimpton, 2006

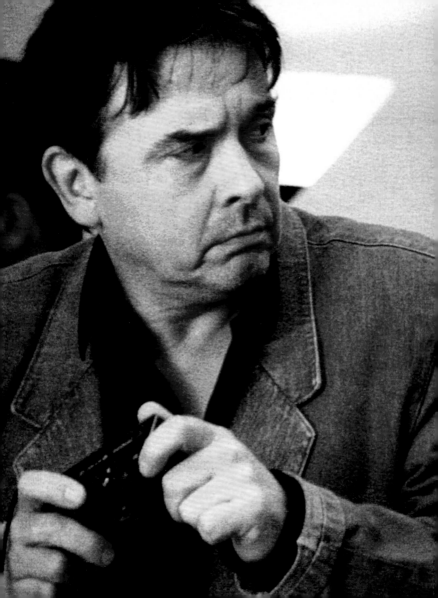

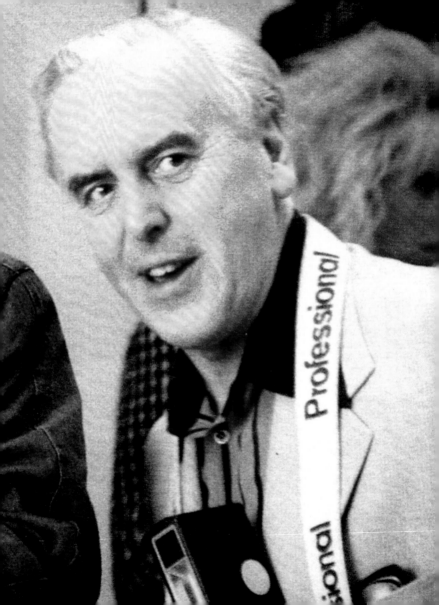

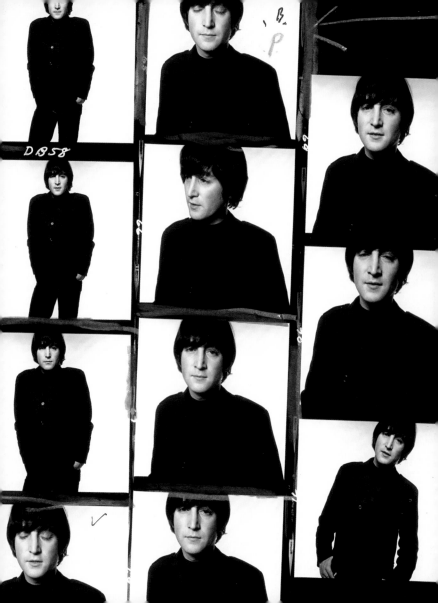

Bailey:

"No one knows what I fucking do. They think I do black-and-white photos of John Lennon."

Bailey:

"Most photographers are a boring lot aren't they? They come in and take hours, taking Polaroids and four hours later they take a picture. You wonder what all the fuss is about sometimes. I'm very quick. Ten minutes, that's about enough time for a portrait."

David Hemmings in Michelangelo Antonioni's film *Blow-Up* (1966)

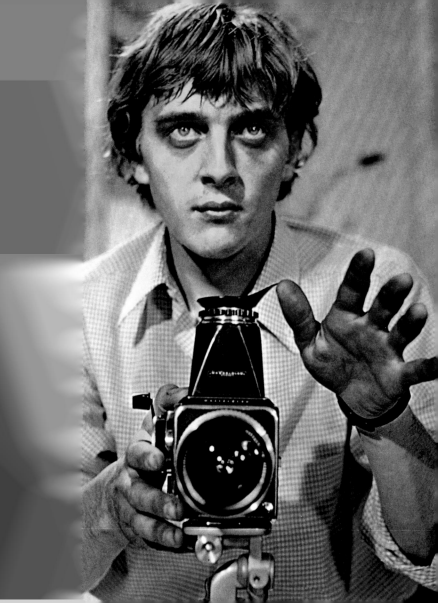

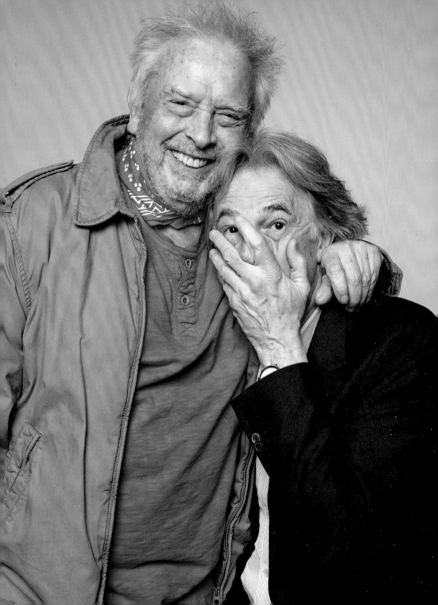

Paul Smith:

"The first time he photo-graphed me he spent an hour chatting and then eventually took one picture with a Rolleiflex camera. He sat on a window sill and I sat on a stool – he just used natural light, and that was it. He just took the one shot and then said, 'All right, fuck off.'"

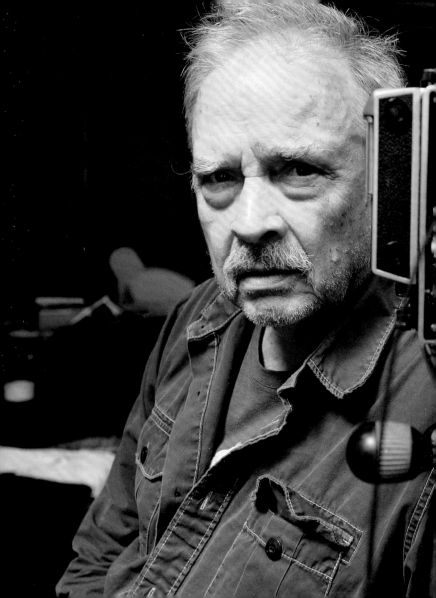

Bailey:

"Digital is a bit like socialism. It makes everything the same and boring. But I think for the general public it's great that you can just do a digital picture and go back and print it on your computer.

Previous pages:
Bailey by Julian Simmonds, 2008

I still use film. The film I use costs about £50 each time I click the camera. In a way photography has become the folk art of the people now, because everybody can be an artist now, to a certain level."

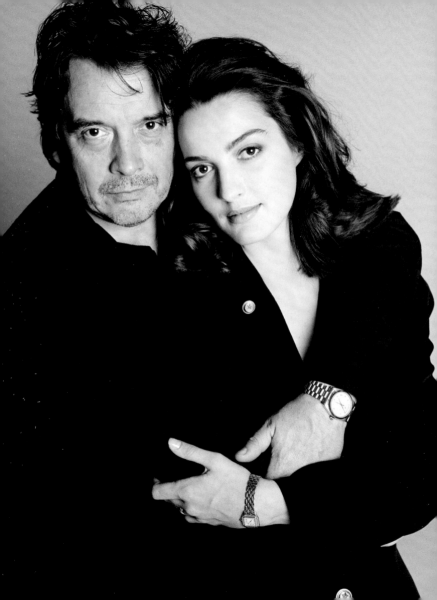

"I'm lucky in my personal life – I've got such a great wife. She's the best thing that ever happened to me, maybe, besides being born. She's a beauty in the classical sense – she's a Roman beauty, really. She's got the long neck and the big eyes and the smallish head. She just looks like one of those Roman busts to me. Something you can't put your finger on – it's a mystery, really."

Mr & Mrs Bailey by Terence Donovan, 1986

Bailey:

"I don't think you're ever successful.
I think if you become successful
artistically – as opposed to financially
– you might as well stop and play chess,
like Marcel Duchamp. There's no point
going on.

I'm distressed every time the contact
sheets come back, every time I see
the results of a job: I think, 'My God,
after fifty years of mucking about with
photography I'm still getting it wrong.'
I get it wrong all the time, and it's so
depressing that I want to keep trying."

David Hockney contact sheet, 1969

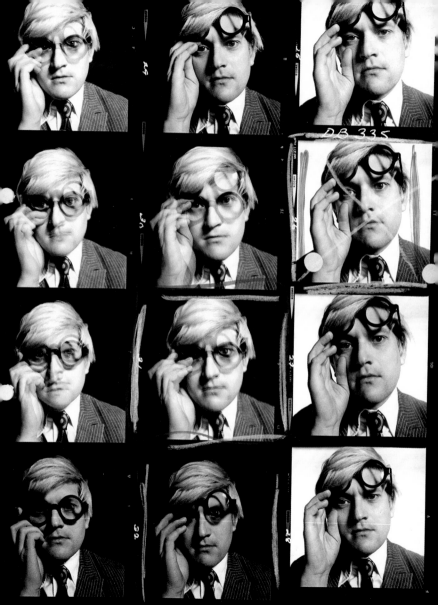

DB 335

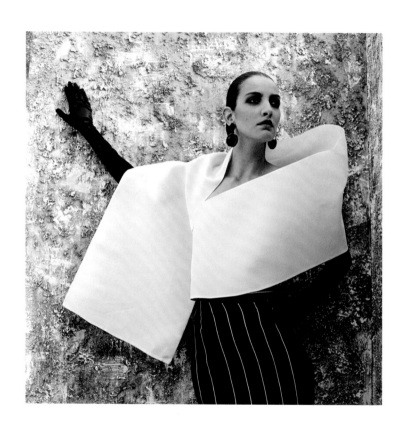

Catherine Bailey, 1986

Catherine Bailey:

"I think life's the main thing in Bailey's work ... He has a way of making it seem flippant, but he's not a joker – he takes what he does very, very seriously. And he's never satisfied – it's always a disappointment, so he just wants to do better. His disappointment doesn't make him give up, it makes him do more."

"He wants to know everything about everyone. And the questions he asks! I'm always amazed people answer them."

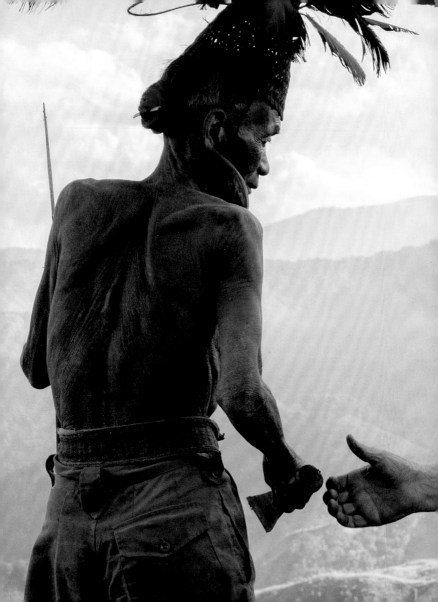

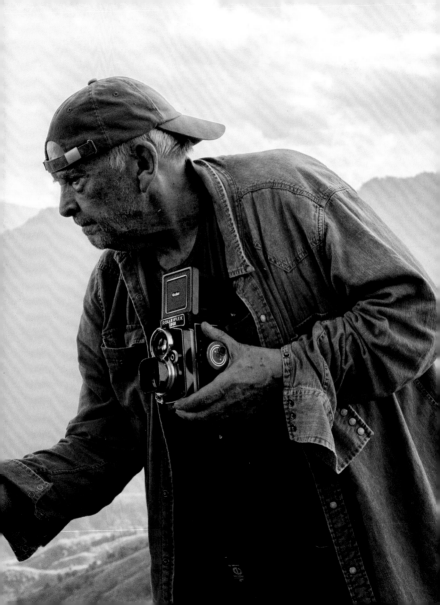

Bailey:

"Curiosity is everything. If you don't have curiosity, you don't have anything. That's the thing that keeps you going."

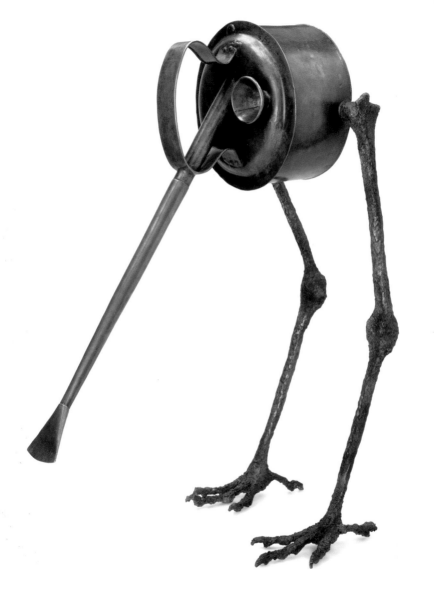

"Photography's all about death, really. That's a sad thing about photography, because when you look at pictures, especially old pictures, they're always dead. When you look at a painting, you don't think, 'Oh, she's dead.' But you look at a photograph and you think, 'Oh, she's dead.'"

Human Skull and Blue Roses, 2008

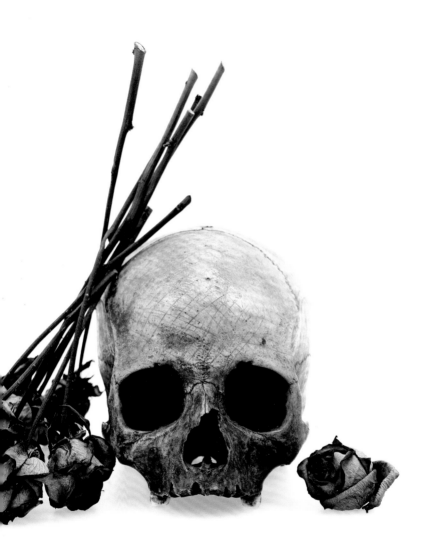

Damien Hirst:

"He's the master of a visual language ... and the few photographers who have matched him are dead. He's an artist and he did much more than define a decade. He's continued to define the world around him for the last fifty years."

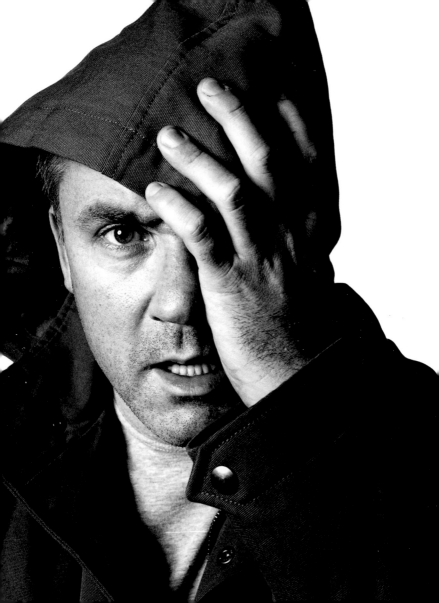

Flower Pots, 2008

Sources

Quotations extracted from the following sources:

Books

Beaton, Cecil and Buckland, Gail, *The Magic Image: The Genius of Photography from 1839 to the Present Day* (Weidenfeld & Nicolson, 1975).

Donovan, Terence, preface to Bailey, David, *Beady Minces* (Matthews Miller Dunbar Ltd and David Bailey, 1973).

Marlow, Tim, 'Bailey and Portraiture', preface to Bailey, David, *Bailey's Stardust* (National Portrait Gallery, forthcoming 2014).

Melly, George, preface to Bailey, David, *If We Shadows* (Thames & Hudson, 1992).

Williams, Kenneth (ed. Russell Davies), *The Kenneth Williams Diaries* (HarperCollins, 1994).

Articles and features (in print and online)

ePHOTOzine interview posted 9 March 2009 (www.ephotozine.com/article/david-bailey-interview-11269).

'What I've Learned – David Bailey', *Esquire* magazine website (www.esquire.co.uk), interview by Johnny Davis, posted 16 August 2012.

The Face magazine (London), no. 56, December 1984.

'"I was young and foolish ...": The truth about David Bailey's legendary way with women', *Independent* website (www.independent.co.uk), posted 28 February 2010.

Photo District News website (www.pdngallery.com/legends/bailey/interview01/shtml), interview by Charles Gandee, New York, 2000.

'Exclusive interview with David Bailey', *Professional Photographer* website (www.professionalphotographer.co.uk), interview by Grant Scott, posted 11 February 2010.

Ellison, Jo, 'Rogue's Gallery' in British *Vogue*, June 2010 issue.

'The Culture Edit' blog on the London premiere of *We'll Take Manhattan* (BBC TV, 2012), British *Vogue* website (www.vogue.co.uk), posted 16 January 2012.

Television programmes

A Brush with Fame (Sky Arts, 2009); interview by presenter John Myatt.

CBS News feature on Bailey's New York National Arts Club Lifetime Achievement Award, 2008; interview by Anthony Mason.

David Bailey: Four Beats to the Bar and no Cheating (LuFilms, 2010; director Jerome de Missolz).

Fashion, Fame and Photography: The Real Blow Up (BBC, 2002; producer Elaine Shepherd).

The Man who Shot the Sixties (BBC, 2010; director Linda Brusasco).

Seven Photographs that Changed Fashion (BBC Scotland, 2009; producer/director Richard Bright); interview by presenter Rankin.

Acknowledgements

I would like to thank Catherine Bailey and my team: Mark Pattenden, Sarah Brimley and Fenton Bailey. Thanks also go to Christopher Tinker, Ruth Müller-Wirth and Robert Carr-Archer at the National Portrait Gallery; and designer Matthew Young.

David Bailey

Fenton Bailey, Sarah Brimley and Mark Pattenden, 2013

Picture Credits

All images copyright © David Bailey, except the following:

Bailey on a stool at *Vogue* (photographer unknown), 1965. © Associated Newspapers/Rex Features • Bailey by Terry O'Neill, 1965. © Terry O'Neill. National Portrait Gallery, London (x125464) • Nadar (Gaspard-Félix Tournachon), self-portrait, *c.*1855. © GL Archive/Alamy • John Huston, 1965. *Vogue* magazine • Catherine Deneuve with a flamingo, 1968. *Vogue* magazine • Ernie Wise and Eric Morecambe, 1970. *Vogue* magazine • Bailey in 1962 (photographer unknown). © Associated Newspapers/Rex Features • Bailey photographing Sue Murray by Terry O'Neill, 1965. © Terry O'Neill/Hulton Archive/Getty Images • Bailey by Patrick Lichfield, 1969. © Lichfield. National Portrait Gallery, London (x128480) • Dudley Moore and Jean Shrimpton, 1965. *Vogue* magazine • Grace Coddington, 1966. *Vogue* magazine • Bailey with Jean Shrimpton and Sue Murray by Terry O'Neill, 1965. © Terry O'Neill/Hulton Archive/Getty Images • Bailey and Catherine Deneuve at St Pancras Town Hall registry office in London after their marriage ceremony, 1965. © PA/PA Archive/Press Association Images • Bailey and Catherine Deneuve in a car in London, 1966. © Ted West/Getty Images • David Bailey, Brian Duffy and Terence Donovan by Arnold Newman, 1978. © Arnold Newman/Getty Images. National Portrait Gallery, London (NPG P150(45)) • Sophia Loren on the cover of *Vogue*, July 1965. *Vogue* magazine • Bailey by Cecil Beaton, 1965. © Cecil Beaton Studio Archive, Sotheby's London. National Portrait Gallery, London (x14019) • Bailey by John Swannell, 1970. © John Swannell/Camera Press. National Portrait Gallery, London (P717(1)) • Queen Elizabeth II meets David Bailey at the British Clothing Industry Reception, Buckingham Palace, London, 16 March 2010. © Associated Newspapers/Rex Features • Bailey with George Cole, commercial for Olympus cameras, early 1980s. Directed by Roger Woodburn with Park Village. Image Courtesy of The Advertising Archives • David Hemmings in Michelangelo Antonioni's film *Blow-Up*, 1966. © Pictorial Press Ltd/Alamy • Bailey at his studio in London, 2008 © Julian Simmonds/*The Sunday Telegraph* • David and Catherine Bailey by Terence Donovan, 1986. Terence Donovan Archive/Getty Images

Published in Great Britain by National Portrait Publications,
National Portrait Gallery, St Martin's Place, London WC2H 0HE

For a complete catalogue of current publications, please write to the
National Portrait Gallery at the address above, or visit our website at
www.npg.org.uk/publications

First published 2013

ISBN 978 1 85514 466 8

A catalogue record for this book is available from the British Library.

10 9 8 7 6 5 4 3 2 1

Managing Editor: Christopher Tinker
Production Manager: Ruth Müller-Wirth
Designer: Matthew Young

Printed and bound in Italy

Frontispiece: Bailey at *Vogue*, 1965

Sold to support the National Portrait Gallery, London

FSC
www.fsc.org
MIX
Paper from
responsible sources
FSC® C016114